Lent Then and Now

People, Poems, and Portraits

ImagoPoetica
Available on Amazon.com and Lulu.com
Hummelstown, PA 17036

Lent Then and Now

People, Poems, and Portraits

Joseph Gascho

Contents

Introduction..........7

 Day 1: Ash Wednesday: Mary..........8

 Day 2: Lazarus 10

 Day 3: Nicodemus..........12

 Day 4: The Woman Who Anointed Jesus..........14

First Sunday of Lent..........17

 Day 5: The Mother of James and John..........18

 Day 6: The Man in the Triumphal Entry Crowd..........20

 Day 7: The Street Cleaner after the Triumphal Entry..........22

 Day 8: The Owner of the Colt..........24

 Day 9: The Daughters of Jerusalem..........26

 Day 10: The Man Who Rented Out the Upper Room..........28

Second Sunday of Lent..........31

 Day 11: The Woman Who Baked the Bread for the Last Supper..........32

 Day 12: The Man Who Sold the Wine for the Last Supper34

 Day 13: Satan..........36

 Day 14: Judas..........38

 Day 15: The Disciples Praying with Jesus at Gethsemane40

 Day 16: The Servant Whose Ear Was Cut Off..........42

Third Sunday of Lent..........45

 Day 17: The Servant Girl..........46

 Day 18: Peter..........48

 Day 19: Pilate..........50

 Day 20: Pilate's Wife..........52

 Day 21: Barabbas..........54

 Day 22: The Carpenter Who Built the Cross..........56

Fourth Sunday of Lent..........59

 Day 23: Simon of Cyrene..........60

 Day 24: The Soldier Who Nailed Christ to the Cross..........62

 Day 25: The Unrepentant Thief..........64

Day 26: The Repentant Thief..........66

Day 27: The Doctor at the Cross..........68

Day 28: The News Videographer..........70

Fifth Sunday of Lent..........73

Day 29: Mary Magdalene..........74

Day 30: The Chief Priests..........76

Day 31: The Soldier Who Pierced Christ's Side..........78

Day 32: Jesus' Dog..........80

Day 33: Golgotha..........82

Day 34: Hell..........84

Sixth Sunday of Lent: Holy Spirit..........87

Day 35: The Sun..........88

Day 36: The Weatherman..........90

Day 37: Joseph of Arimathea..........92

Day 38: The Owner of the Tomb..........94

Day 39: Good Friday: The Guard at the Tomb..........96

Day 40: Holy Saturday: The Caretaker of a Jerusalem
 Cemetery..........98

Seventh Sunday of Lent: Easter; God..........101

Jesus..........103

About the Author..........104

Introduction

Lent is a time to reflect on the events leading up to the crucifixion of Christ. I too often assume that the people in the narrative knew what was about to happen, but surely they did not. It's been helpful for me to try to put myself into their shoes, at the time they lived. The poems in this volume are the result of that reflection. And to further attempt to look at these events in a new way, I've made accompanying portraits of 21st century people, sometimes with a deliberate "mismatch" of women linked with male Biblical cha-raters. Almost all the poems are about human characters in the Lenten story, written in a first person point of view. Several poems present a personified point of view of places or objects, such as the sun and Golgotha.

The seven poems for each Sunday of Lent are written in sonnet form, and the forty poems for the weekdays of Lent are written in what I call a hemi-sonnet form—seven lines instead of the tradi-tional fourteen. Throughout, I've attempted to keep to the iambic pentameter format (ten syllables per line with alternating syllables stressed or emphasized), and though I have not chosen to follow a rhyme scheme, I have worked to incorporate the sonnet concept of a discernible "turn" in theme or perspective during the last half or third of the poem. The first five Sunday sonnets are my own person-al reflections, and the last two present the voices of God and the Holy Spirit. The book concludes with an eighth sonnet which invites Jesus' voice.

Mary

How I need my man right now. Worn out
by all the kitchen counter jobs, his heart
gave out. Should have retired when he
was sixty-five like all the other carpenters
whose sons grew up to take their place.
He'd trained our son, who seemed to like the trade
but left us in the lurch three years ago.

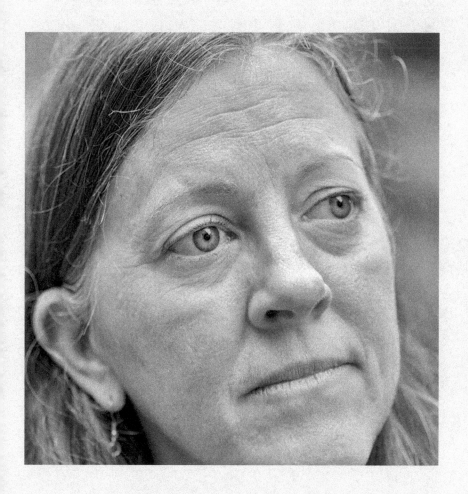

Lazarus

There must have been a terrible traffic jam
or he'd have gotten here in time to say
goodbye. I'd lost my sense of taste and smell.
The ventilator did no good. My time had come.
Next thing I heard, "Rise up!" I wakened
to the stench of death, changed my clothes,
said to myself, "Can anything top this?"

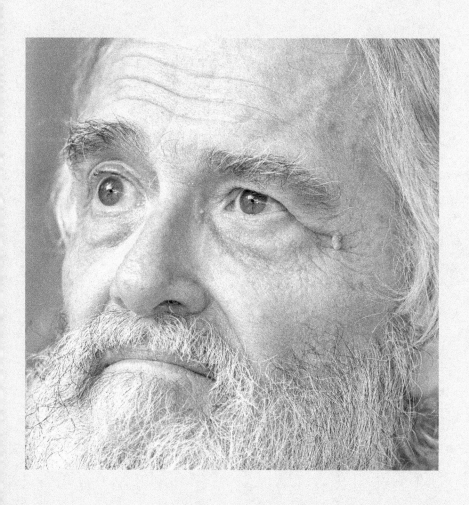

Nicodemus

We rendezvoused at a coffee shop
at 2 a.m. No wiser than before,
I left at 3. To understand this man
I'll have to learn anatomy. Born again?
And then last night we took his body down
and wrapped it up in linen sheets and I
pondered yet again on being born again.

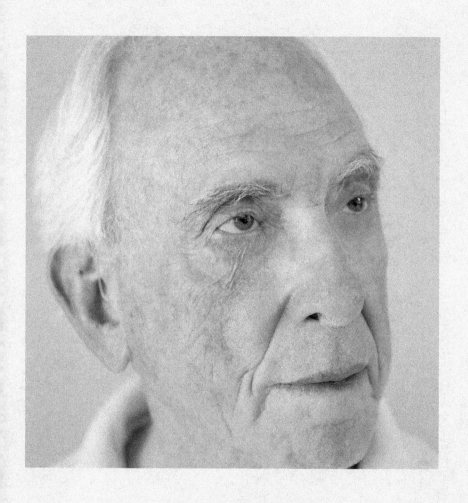

The Woman Who Anointed Jesus

I worked overtime at the Safeway
register, ringing up the groceries
so I could buy the sweet perfume.
I sprayed it on, was told, "Now that is you."
And then I had the dream and knew I had
to crash the party, crack the jar, anoint
his precious feet, because of who he was.

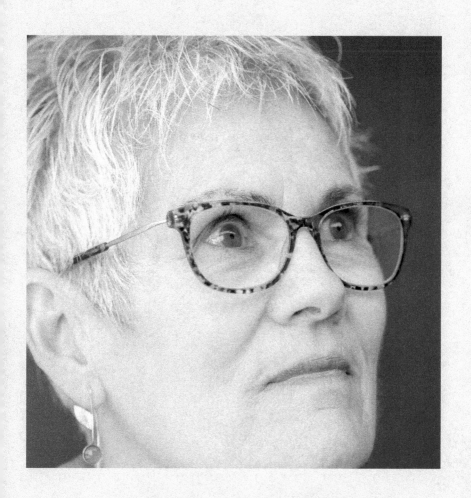

First Sunday of Lent

The Wednesday evening daubing lasted
half an hour, was washed off by a late
November rain as I raced from church
to car. But in the vestibule before
I fled I snapped a selfie, making sure
I was alone—what would the minister
(or some five-or-six-year-old) think
of me, a proper man of seventy-three?
My pious friends tell me the least that I
can do is put away my phone for Lent,
say I should meditate on Gospel texts,
avoid technology of any kind.
They do not know how often I've reviewed
the image of the ashes on my brow.

The Mother of James and John

Last week we had him come for lunch. After
desert I caught his ear, pleaded
for my sons: "Let them sit next to You
when You are King." (I knew it would be soon.)
I thought him cruel when he declined—
they'd given up their MBA's for him.
But now I'm glad my wishes were denied.

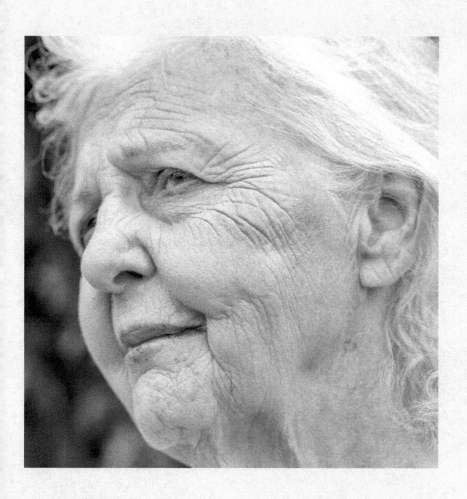

The Man in the Triumphal Entry Crowd

"Alwxa, what on earth is going on?" I asked
when I saw the cheering mob on Market Street,
confetti falling from the windows six floors up.
Could it be our team had finally won?
I watched the limo with the MVP
creep slowly down the avenue. The hero
waving to the crowd was not LeBron.

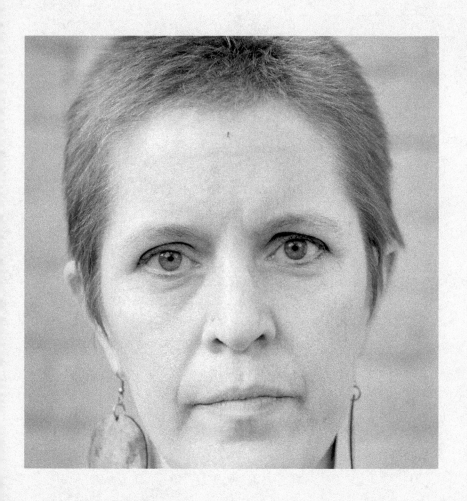

The Street Cleaner after the Triumphal Entry

Twelve baskets and I've only just begun.
Confetti, water bottles, ticket stubs,
palm leaves I will burn to ashes
at the county dump this afternoon—
and a discarded coat—size forty-two—
looks almost new. If it doesn't fit
I'll sell it on the street for thirty bucks.

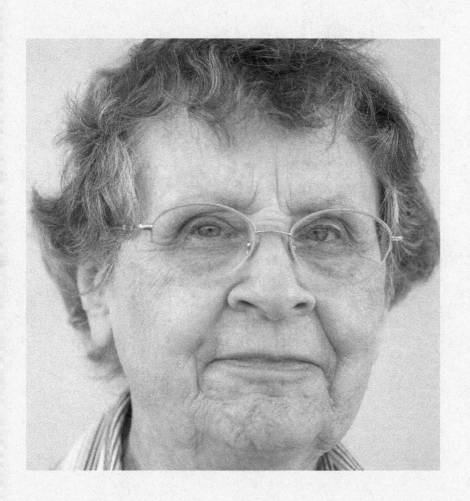

The Owner of the Colt

Had I known a full-grown man would ride
her for an afternoon I never would
have loaned her out. But she came prancing back,
muzzle high, no worse for the wear.
I tried to sell her to a man today
but when he hoisted up his kid, she bucked
him off, as if to say, "For me it's only kings."

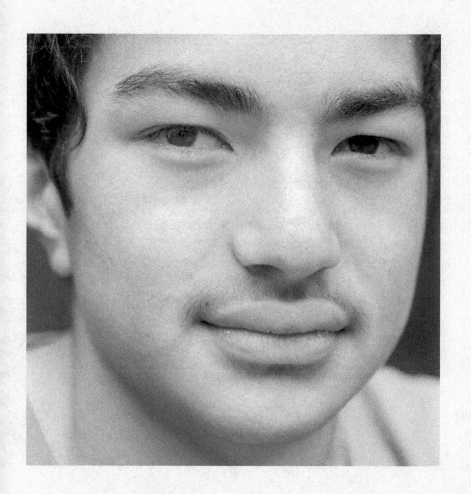

The Daughters of Jerusalem

At bridge today the topic of the gossip
was the man and what was going on
in town and how unfair it was. Someone
bought a card we signed and gave to him.
He glanced at it, then shook his head
and told us, "Ladies, pack your SUV's
and hit the Interstate before it is too late."

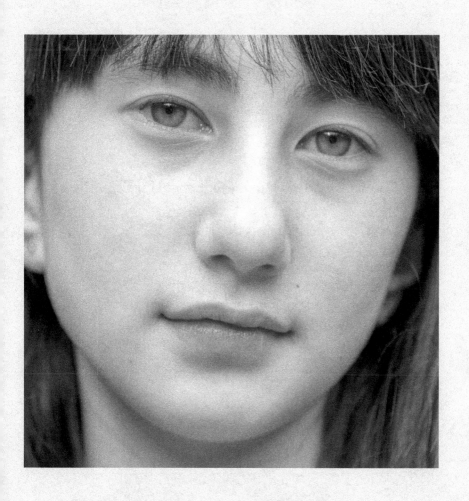

The Man Who Rented Out the Upper Room

My room: the last one in Jerusalem.
I wouldn't budge about the cost. They paid in cash.
A rowdy bunch, 13 of them, all men.
"Keep down the noise or I will call the cops."
They brought their wine and loaves of bread, then rang
for water and a towel. When they left
I asked them, "Should I book you for next year?"

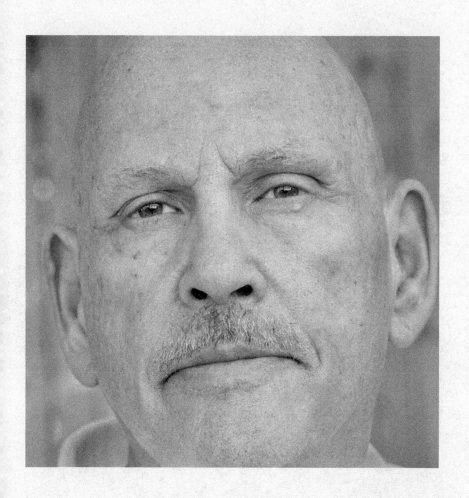

Second Sunday of Lent

I've given up the decadent deserts,
the after-dinner snacks, the scones with tea.
I've given up the coffee and the wine.
Last year it was the chicken, beef and pork.
Smug in all I've given up for Lent,
knowing I will end the giving up
the Monday after Easter Day, that I
can stop the giving up at any time.
And then there is my office friend,
great-grandson of a Mississippi slave
who gave up his dignity when
the township cop pulled him over, wrote
him up, when he hit the rumble strip
dodging potholes as he drove to work.

The Woman Who Baked the Bread
for the Last Supper

He strode into my bakery today
and said, "I need a loaf or two of bread.
Hot from the oven and unleavened, if you please.
Must have enough to serve a dozen plus."
The kind of bread baked by the Israelites
before they fled the mighty Pharaoh's wrath,
that night their first-born sons were spared.

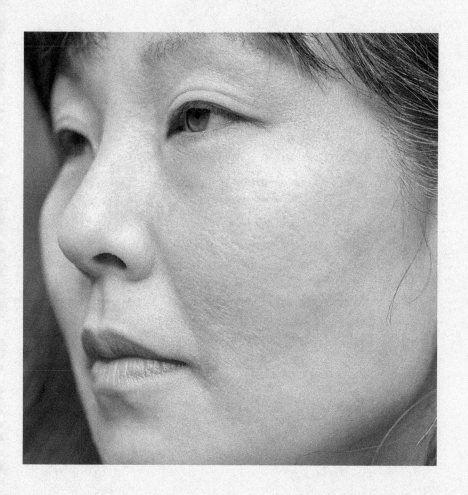

The Man Who Sold the Wine for the Last Supper

He knew his wines, the man who came today.
"Used to make my own," he said. "Got rave reviews
at a wedding feast three years ago.
but I haven't had the time recently."
"What would you like, a Cabernet?" I asked.
"Something with an earthy taste," he said.
"A full-bodied wine is what I want."

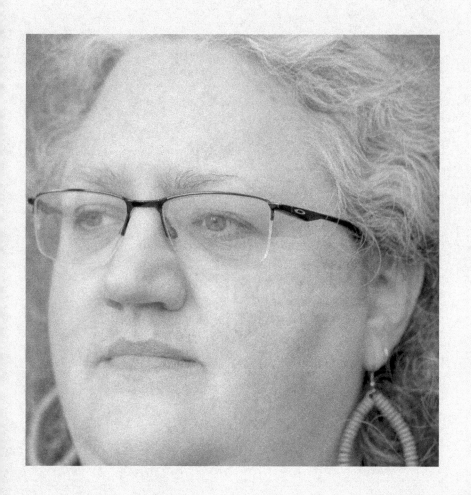

Satan

I could not believe my luck. He grasped
the apple that I dangled from the tree,
gazed longingly, then raised it to his lips—
and—could it be?—he took a bite and chewed
it thoughtfully. But then he stopped—
and spat it on the ground. Bad luck. But there
are other apples, other people on my list.

Judas

You'd think I would have known. Me, the guy
who kept the books and knew he was legit,
me, one of 12 who'd followed him around
for three long years, who saw him walk the talk.
But no. Bombarded by the Twitter feeds
I swapped 280 characters
for 30 coins of gold.

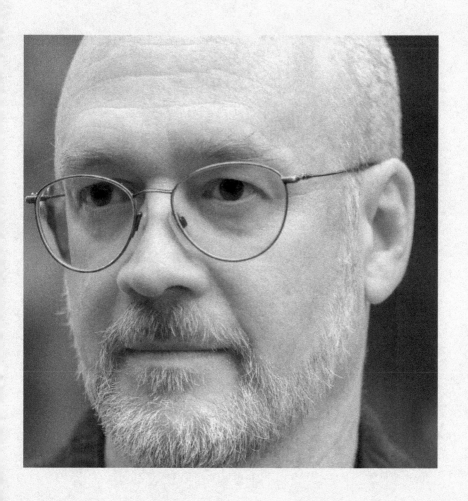

The Disciples Praying with Jesus at Gethsemane

Frantic for an A in "Introduction
to Theology," we caffeinated up,
desperate to stay awake, cramming
for the final that we had next day.
But we fell asleep at 2 a.m.,
flunked the oral portion of the test
even though we got a second chance.

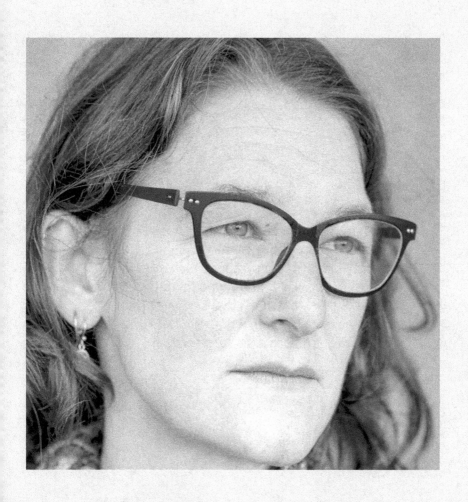

The Servant Whose Ear Was Cut Off

When my ear was back in place, I heard
that earlier today he knelt and washed
the dirty feet of 12, unwrapped a towel
from round his waist and wiped them dry. Before
I had a chance to tell him thanks, he winked
at me (how could he, at a time like this?),
as if to say, "You are a servant, too."

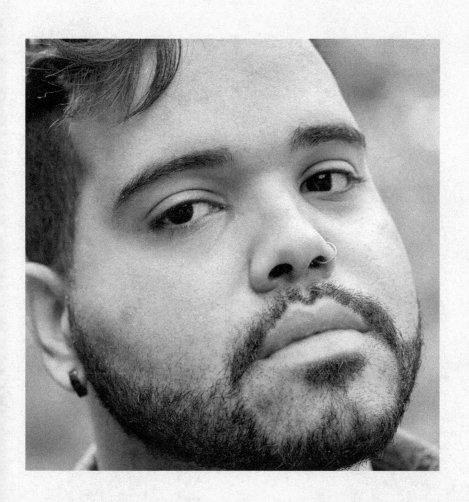

Third Sunday of Lent

My father lent me out when I was twelve.
The farmer down the road needed me
to milk his cows after doctors cut
his cancer out. For forty days I gave
up basketball, biked to his barn at dawn.
In church we never practiced Lent. It was
a Roman Catholic thing. Menno Simons,
we were sure, would have disapproved.
Our Lent took place in the anteroom
back of the church. The bishop grilled us one
by one. "Are your right with God
and man?" We'd search our souls. What had we done
or hadn't done? And if we answered "Yes,"
next day we'd eat the bread and drank the wine.

The Servant Girl

I saw this guy, tight with the healer man
a week ago. You would have thought he was
the one who lased away the cataracts,
who shouted, "Lazarus, rise up!" Now
here he is, squatting at this fire.
"I'm from LA. Flew in today," he says.
"Who is that guy who's looking straight at me?"

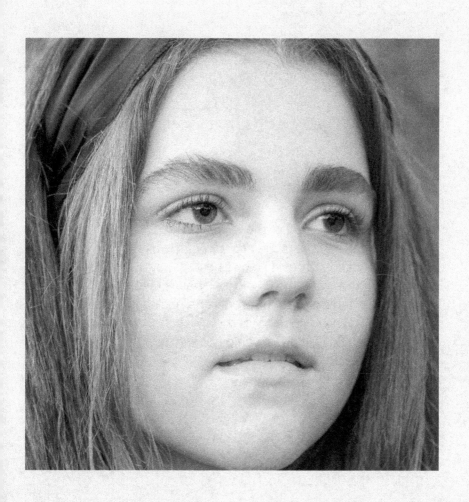

Peter

Above the hissing of the whip against
his back, he heard the crowing of the bird
and looked at me. He didn't have to say
again the words he'd said four hours before.
I could have wrung that rooster's neck but knew
it would do no good to kill the messenger.
Something Caiaphas would understand.

Pilate

"Are you a King?" I asked, and when
he wouldn't say, I said, "What have you done?"
and when he started going on and on
about the truth, I asked him, "What is truth?",
called for a basin, washed and dried my hands
and told the multitude his blood was not
on me. I hope to God that is the truth.

Pilate's Wife

It took two cups of coffee and a half
an hour to realize it was a terrible dream
and not him, standing at my bed,
telling me the gospel truth.
I wrote a note and rushed it to my man,
When he got home that night, he laughed at me,
told me, "Throw away that book by Freud."

Barabbas

By rights I'd be the one nailed to the cross,
but the jailer opened up my cell
and set me free and now I'm fleeing town
before they figure out how wrong they were.
I'm sorry for this guy who'll take my place,
but if you were me, what would you do?
If I go back, it will be both of us.

The Carpenter Who Built the Cross

Finish work is all I've ever done.
Wainscoting, crown molding is what I put up.
But the Romans stuck me with this task.
I couldn't turn it down, I have to pay my rent.
I plane, then sand the boards with utmost care,
then run my ungloved hand across the oak.
Don't want any splinters sticking out.

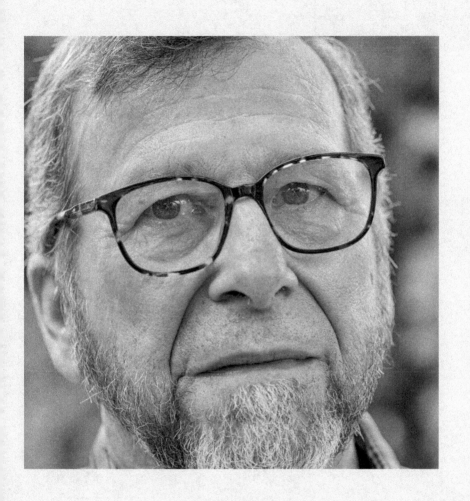

Fourth Sunday of Lent

Deprivation is the usual discipline
for those who practice Lent. Giving up
dark chocolate, whiskey and cigars,
fasting once a week, sleeping in a single bed.
Things I've never had the fortitude
to sacrifice for even seven weeks.
Depravation is a noble discipline
for many folks, I am quite sure.
But I have found there is another way
to commemorate this somber time.
Wrapping bandages on weeping wounds,
stenting open coronary arteries,
shocking fibrillating ventricles,
gripping the pen and writing down the word.

Simon of Cyrene

My luck. Had I not downed the second beer,
flirted with the blond, before I left
the bar, played another 8-ball game,
I'd not have been the brawny man they nabbed
to lug the cross. I could not say no.
I didn't want to hang on one myself.
I carried it for him for half a mile. My luck.

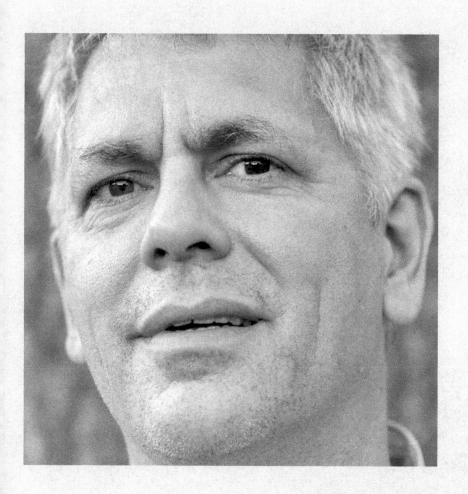

The Soldier Who Nailed Christ to Cross

Why they chose me I will never know.
I'd never had a hammer in my hand before.
A wonder that I didn't smash my thumb.
Would not have been the best of times to swear.
My task was going well I thought until
he asked me, as I drove the nails in,
"Did you know I am a carpenter?"

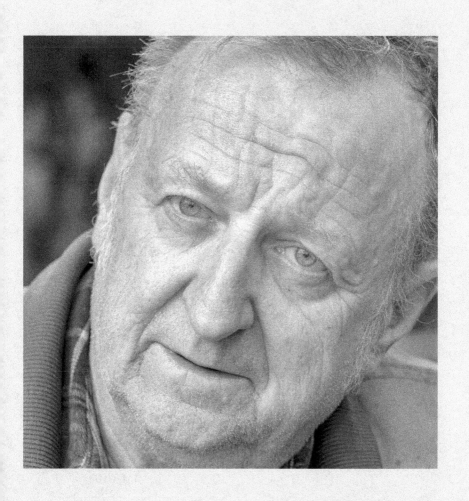

The Unrepentant Thief

What got me hanging here: the loaf of bread
I stole to feed my empty-bellied wife.
My check from disability ran out
three months ago, my credit card maxed out.
Had he been in my shoes, I bet the judge
who sentenced me would have done
the deed I did. I will not repent.

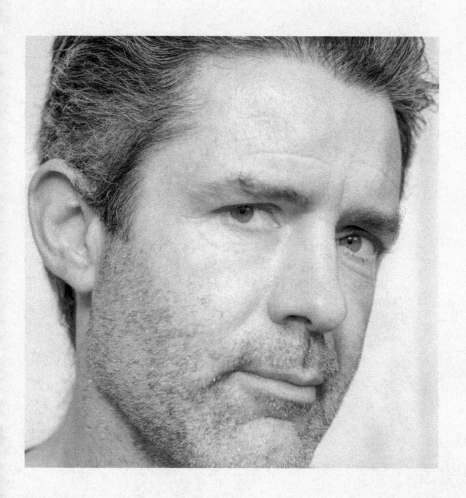

The Repentant Thief

A bounty on my head for thirty years—
and then the sheriff nabbed me pilfering
the diamonds I was going to fence to fund
the local foodbank for another year.
I meant no harm, but will repent, hanging here
with one who filled the hungry with good things,
and sent away the rich with empty hands.

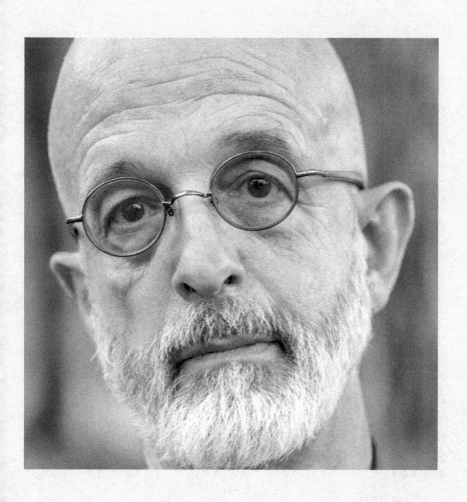

The Doctor at the Cross

They asked me to pronounce him dead and so
I climbed the ladder, put my fingers
on his wrist and found no pulse, lay
my ear against his chest and heard no beat.
They asked me, "Do you know the cause of death?
"Asphyxiation? Pulmonary embolism?"
"No," I said. "It was a broken heart."

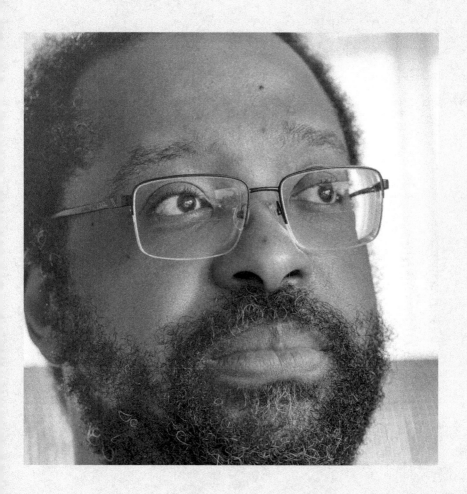

The News Videographer

My friends tell me, "Had you been there to film
the nailing on, the taking down,
the laying in, the rising up, we'd get
our foreheads daubed, sing in the Easter choir."
But I've been at my job long enough
to know the pundits would have analyzed
the tapes, declared them fake, had them erased.

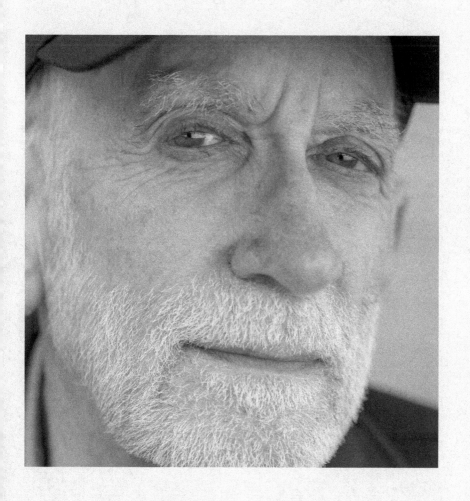

Fifth Sunday of Lent

Forty years of desert wandering
for the unbelieving Israelites.
Forty weeks each of us resides
inside our mother's uterus.
For forty days and forty nights He stuck
it out, nothing to eat or drink.
Forty hours from Friday afternoon
until the dawn of Easter day.
All I ask of myself this year:
for only forty minutes once a day
try to set aside my monkey mind,
think on the bread and wine, the crown of thorns,
the crosses and the vinegar, the empty tomb.
Dear God, I pray, will forty seconds do?

Mary Magdalene

Standing here, looking up at him,
helpless as a handcuffed prisoner,
I think about the demons that he drove
from me. If I could only bring them back!
I'd sic them on these scribes and Pharisees,
this frenzied mob of people fed fake news,
these soldiers with their hammers and their nails.

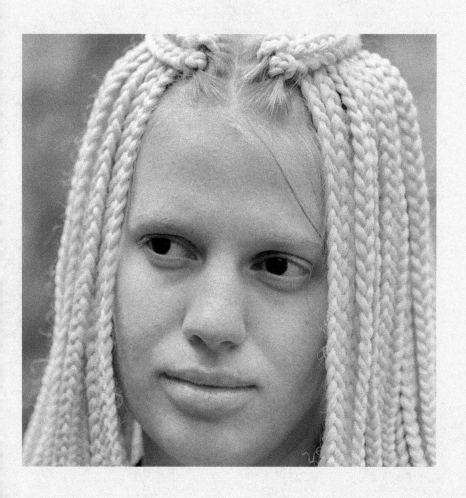

The Chief Priests

We would have liked to spend the thirty bucks
to stock our coffers with a block of well-aged cheese,
a case of Cabernet, caviar,
Havanas for our humidor,
but if someone had leaked that to the press...
on second thought, the money will be used
for some good cause. We are very ethical.

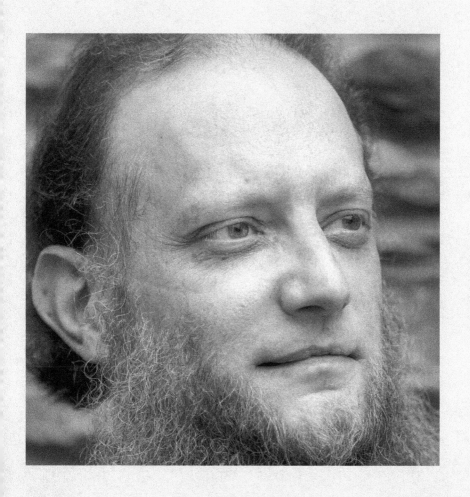

The Soldier Who Pierced Christ's Side

He'd hung there long enough, was still alive
they thought, so I was sent to break his legs.
But He was dead. "Pierce his side," they said.
It made no sense but soldier that I was,
I jabbed my spear into his flesh.
More real than the bishop's pouring on.
Baptism of water and of blood.

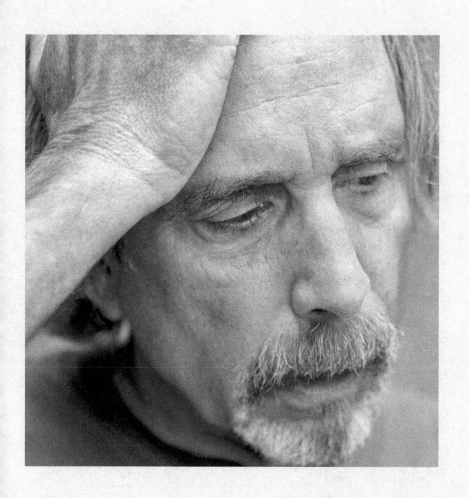

Jesus' Dog

You never read of me in Matthew, Mark,
or Luke or John. But I was there. Some scribe
deleted what they wrote. A runt, he'd picked
me from the litter and I stuck with him
for three long years, cringed at the whip, the jeers,
the hammer blows, lay down beside the cross,
alone when Peter, James, and John had fled.

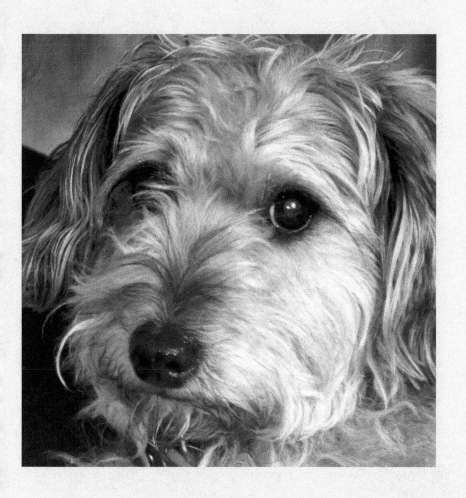

Golgotha

This time of year the workers dig their holes
into my side, drop in their crosses, one
or two or three. Nothing I can do.
I never get accustomed to the screams.
I thought I'd heard and seen it all—
been here so many years. But then tonight
I heard, "Why have you forsaken me?"

Hell

We had an unexpected guest today.
The mercury plummeted 15°
before we had a chance to stoke the fire.
If he had stayed, what would we have done?
He poked around in every corner of the place
but then, thank God (something we never do)
he left before the place froze over.

Sixth Sunday of Lent
Holy Spirit

This breath that first was breathed by Spirit
hovering above the darkness and the void,
this breath that filled the lungs of Moses
when he told the Pharaoh, "Let my people go,"
this breath that let the harlot Rahab
tell the spies where they could hide,
this breath that's blown into the saxophone,
that formed the words that flowed from Heaney's pen,
this breath inhaled by Gabriel
as he flew from heaven to Mary's side,
this breath that bore the message Joseph heard,
to take his Mary for her word,
this breath that came from one who said, "It
is finished," "Take this cup," this breath has ceased.

The Sun

Twenty centuries from now
the scientists and preachers both will want
to know and so, to set the record straight,
I will make it very clear. Not
a single cloud was in the sky. No moon
was in the way. It was me and only me,
hiding my face for three whole hours.

The Weatherman

I've memorized my isobars and tidal charts,
know all about pollution indices.
I was the only one to prophesy
the hurricane that hit Jerusalem.
But darkness for three hours in the middle
of the afternoon? How will I explain
it on the news at 10 p.m. tonight?

Joseph of Arimathea

I climbed the ladder, pulled the hands and feet
out from the nails, took the body down,
laid it in my Volvo trunk and drove
through side-streets and alleys to the funeral home,
eyes on the rearview mirror for flashing lights,
ears tuned for sirens, thinking to myself:
How will I explain? Will I be next?

The Owner of the Tomb

The wife got mad, said I should have asked
her first before I lent it out. "If he's
in it, where will they bury you and me?"
she asked. "They paid in cash, more than I asked,
enough to pay the mortgage off, and more.
And, I wouldn't be surprised at all
if something opened up," I said.

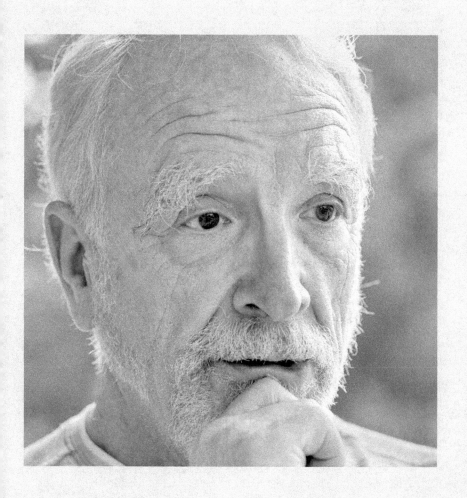

The Guard at the Tomb

These chanting, praying, sobbing Mary's are
no threat. The door's a two-ton block of stone.
I lay back in my chair, while away the hours
texting friends about the crazy goings on.
Before I took my post my boss told me,
"Be sure you don't let anyone break in."
His worry: someone breaking in.

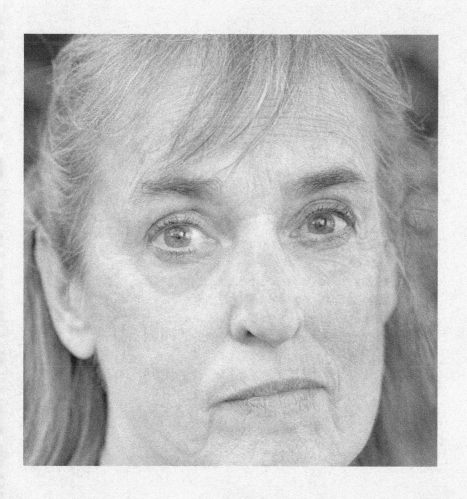

The Caretaker of a Jerusalem Cemetery

I hope there's money in the budget for
the score or more of men I need to hire
when the Sabbath's past. It will take a month
or two at least for them to do their task.
They can't be squeamish for what they must do
is dig new graves and bury yet again
the corpses that the quake brought up today.

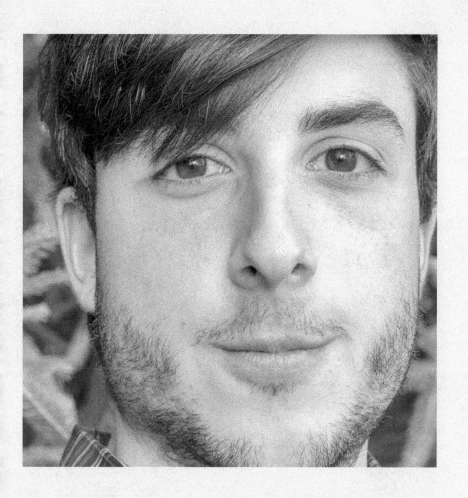

Seventh Sunday of Lent
God

What he said while hanging on the cross
put theology back two thousand years.
The "Why," the "Thou," but most of all
"forsaken me." Scholars will question
if I know it all, if I care at all,
if I can do it all, if I love at all.
It will dig a chasm that will seem
impossible to span with any bridge.
Too bad the scribes to whom I said
"Take down these words," did not listen—
or if they did, could not comprehend,
or if they could, would not believe
that I, hanging there myself (yes, he was me,
and I was him), would say, "It breaks my heart."

Jesus

I made all this 4,000 years ago,
(or four billion years, it matters not
a whit): this awful rocky hill,
this oxygen these creatures breathe,
this ink black sky, this hidden sun, the flax
they spin, the looms they use to weave their cloth,
the wheat they've learned to thrash and turn to flour,
the water that they drink and turn to wine,
the trees, the saws with which they cut the wood,
the spades to dig the holes into the dirt,
the spears they wield to conquer and annihilate,
the hammers they use to drive the nails
they have forged from my iron ore,
the nails they drive in one by one.

The Author

Joseph Gascho, a semiretired cardiologist and Professor of Medicine and Humanities at Penn State University College of Medicine, has published poems in a wide range of medical and non-medical journals, including numerous commended poems at the annual International *Hippocrates Society of Medicine and Poetry* competition. Joseph won the 2014 *Annals of Internal Medicine* poetry competition and has published a first book of poetry entitled *Cornfields, Cottonwoods, Seagulls, and Sermons: Growing Up in Nebraska* [DreamSeeker Books, 2017]. Through Lulu he has also self-published *Advent Then and Now. People, Poems and Portraits* [2020].

Joseph is also a photographer and has several permanent photography exhibits related to the humanity of patients and health care workers at the Penn State University College of Medicine. He has had a photography exhibit at Positiveexposure109, on museum mile in New York City. His photographs have been published on the cover of *Annals of Internal Medicine*, and one of those photographs, in 2009, won Photograph of the Year.

Joseph is interested in the interaction of word and image and has had numerous image-and-word poems published.. He is married to Barbara Brunk, who is a retired nurse and chaplain in an ALS clinic. He has a son who is a harpsichordist, a daughter who is a minister, and four grandchildren.

Joseph is a member of Community Mennonite Church of Lancaster, Pennsylvania.

CPSIA information can be obtained
at www.ICGtesting.com
Printed in the USA
LVHW042234220822
726571LV00002B/337